AMERICAN
WORKS ON PAPER
II

Autumn 1988

SPANIERMAN / DRAWINGS

Betty Krulik, Director
By appointment 50 East 78th Street New York, New York 10021
Tel. (212) 879-7085, ext. 33 Fax. (212) 249-5266

Design: Marcus Ratliff Inc.
Composition: Trufont Typographers
Lithography: Thorner-Sidney Press, Inc.

ISBN: 0-945936-01-X

The collection presented in our second S P A N I E R M A N / D R A W I N G S catalogue reflects the diversity and vitality of drawings, pastels and watercolors by American artists of the nineteenth and twentieth centuries. Although our aim is not to present a complete survey, we are pleased to include seventy works from many key periods of American art. These begin with James Henry Cafferty's whimsical genre scene of a vagabond executed in 1848, and continue into the nineteenth century with Ruskinian realist landscapes by Henry Farrer and William Trost Richards. Henry Farny's two masterworks represent the American West at the turn of the century.

Among the Impressionist works are Mary Cassatt's extremely spontaneous pastel of her charming and sophisticated young neighbor, *Simone*, a crisp watercolor of Washington, D.C. by Childe Hassam, and a pastel expressing the freshness of the Connecticut landscape in spring by John Henry Twachtman. A watercolor of S. Giorgio Maggiore exhibits John Singer Sargent's love of Venetian light. Modern outdoor life in the early 1900s is shown in Maurice Prendergast's sketchbook containing fifty-seven images of Boston and Marblehead, fourteen of which are brilliantly-colored watercolors.

This catalogue also initiates the expanded scope of our department to encompass works by American Modernists. The 1920s and '30s are especially well represented with two sparkling watercolors by Edward Hopper, an inventive and advanced landscape by Yasuo Kuniyoshi, a freight train by Reginald Marsh expressive of urban America in the 1930s, and abstract works by Abraham Walkowitz, Lyonel Feininger, Alexander Stirling Calder, Byron Browne, Raymond Jonson, and Arshile Gorky. Willem de Kooning's 1951/52 pastel of two women represents the New York School at its most powerful moment.

The gallery is open by appointment, (212) 879-7085, ext. 33, Betty Krulik, Director

ALICE HAWTHORNE ANNAN (Active 1900–1920's)

1. *Across the Arno at Florence*

Watercolor on board
21½ × 14⅞ inches

Provenance:
Private Collection, Connecticut

Exhibited.
St. Louis, MO., World's Fair, Department of Art, 1904.
Baltimore, MD, Baltimore Watercolor Club, *Fourteenth Exhibition*, 1908
Cincinnati, OH, Cincinnati Museum of Art, *Cincinnati Museum Association, Annual Exhibition*, 1909.
Poland Spring, ME, Maine State Building, Poland Spring Gallery, *Fourteenth Annual Exhibition*, n.d.
Worcester, MA, Worcester Art Museum, n.d.
New Orleans, LA, Art Association of New Orleans, n.d.

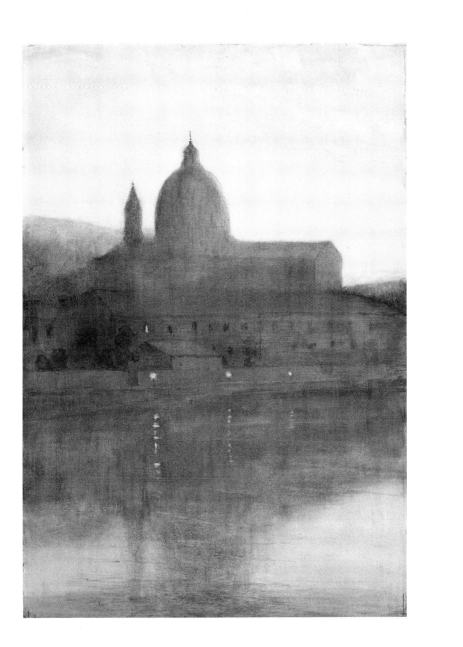

THOMAS POLLOCK ANSHUTZ (1851–1912)

2. *Cape May, 1894*

Watercolor on paper
8¼ × 12⅜ inches
Inscribed lower right: By Thomas P. Anshutz ANA, Edward P.
 Anshutz, Artist's son.

Provenance:
Estate of the artist
Edward Anshutz, the artist's son
Private Collection, New York, NY

This watercolor is closely related to the artist's work executed
 in the 1890's, when he summered at Cape May, along the
 New Jersey shore.

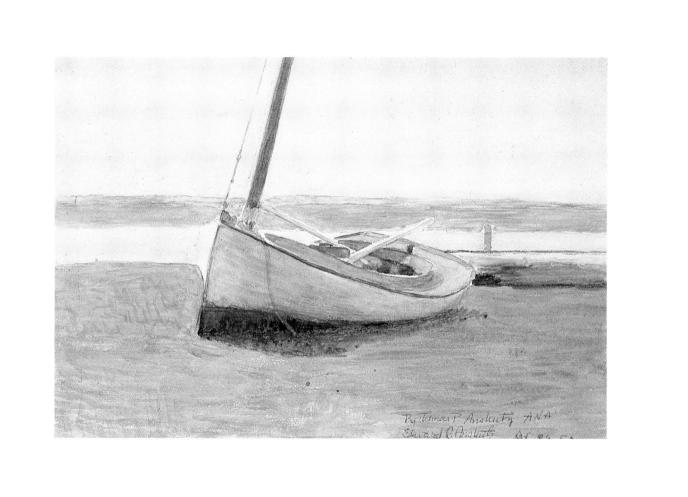

By Thomas P. Anshutz, ANA
Edward C. Anshutz Oct 24 54

WILLIAM P. BABCOCK (1826–1899)

3. *Garland Making*

Charcoal on paper
13½ × 8⅛ inches

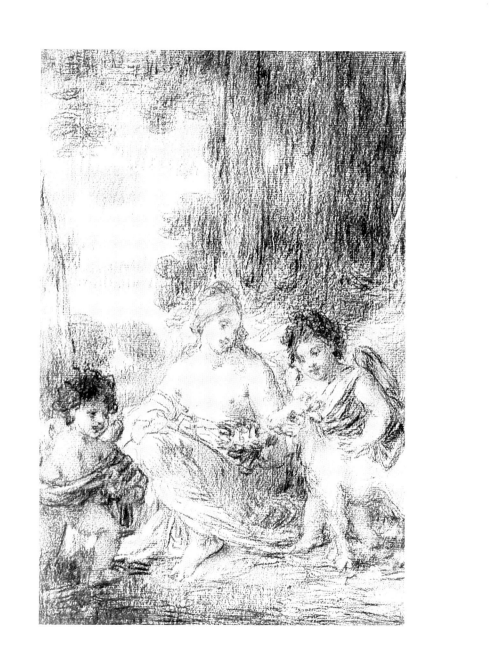

THOMAS HART BENTON (1889–1975)

4. *Young Boy with Cap*

Pen and ink and pencil on paper
8¾ × 6½ inches
Signed lower right: Benton

Provenance:
Private Collection, Florida

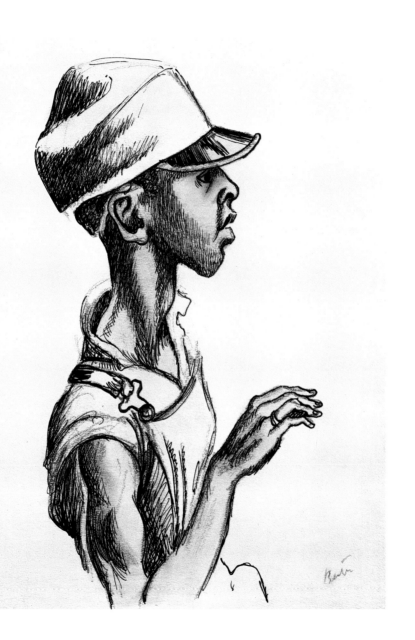

E M I L J A M E S B I S T T R A M (1895–1976)

5. *Omnescience,* Circa 1940

Pencil on paper
23½ × 17½ inches
Signed lower right: Bisttram

Provenance:
Estate of the artist

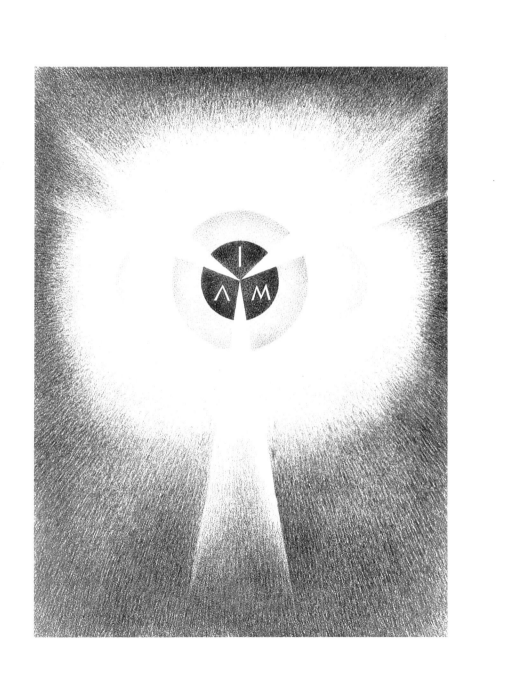

ROBERT FREDERICK BLUM (1857 1903)

6. *The Bullfight*

Pencil on board
17⅜ × 11 inches
Signed and dated lower left: Blum 1883

Provenance:
Private Collection, Birmingham, Michigan

This illustration was for a story entitled "Act of Audacity" in
the November 1883 issue of *The Century*.

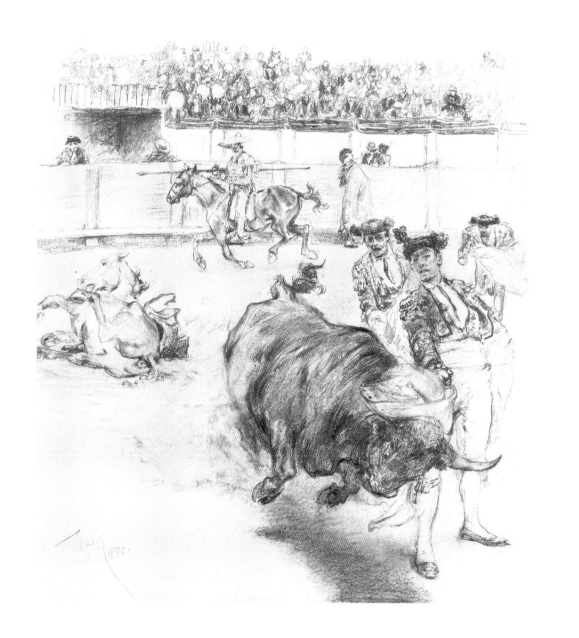

ALFRED THOMPSON BRICHER (1837–1908)

7. *Oyster Boats, Peconic Bay*

Watercolor on paper
14 × 20 inches
Signed lower left: ATBricher

Provenance:
Private Collection, Massachusetts

Exhibited:
Southampton, NY, Parrish Art Museum, *The Long Island
 Landscape 1865–1914, The Halcyon Years*, July 26–
 September 20, 1981, Cat. No. 6

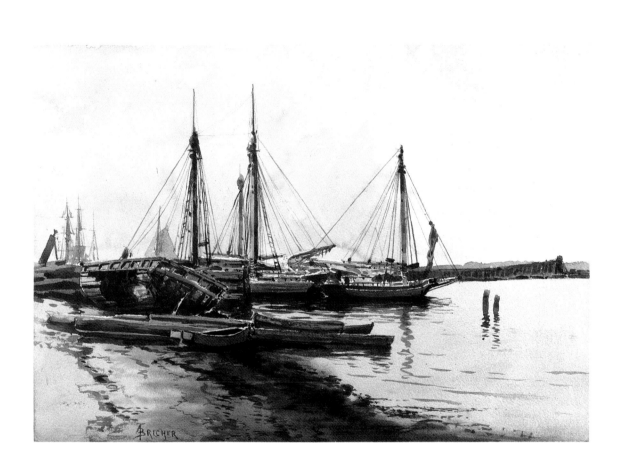

—

JOHN APPLETON BROWN (1844–1902)

8. *The Harvesters*

Pastel on board
14 × 18 inches
Signed lower left: J. Appleton Brown

Provenance:
[Doll and Richards, Boston, MA]

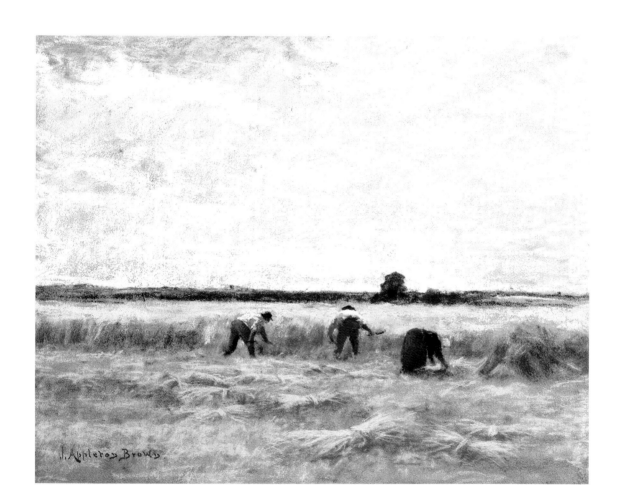

BYRON BROWNE (1907–1961)

9. *Kouros Figures*

Watercolor, gouache and pen and ink on paper
26 × 20 inches
Signed and dated lower right: Byron Browne Aug. 11, 1952

Provenance:
Gift of the artist to his model
By descent in the family of the model

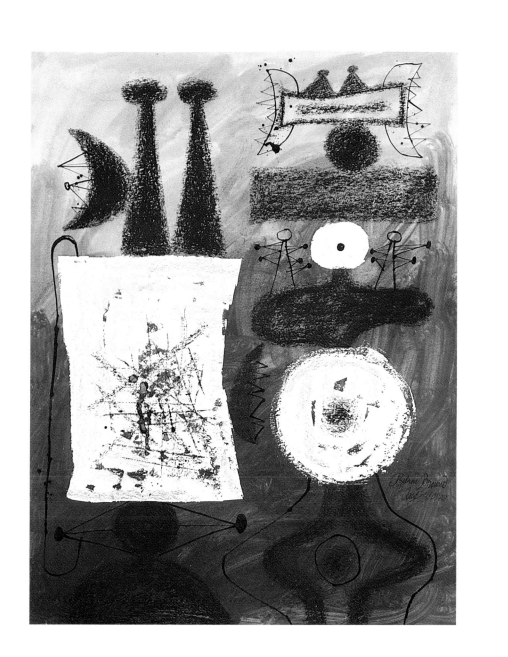

DAVID BURLIUK (1882–1967)

10. *Edgewater Yacht Basin, New Jersey*

Watercolor, gouache, crayon and pencil on paper
12 × 15⅞ inches
Signed lower right: Burliuk

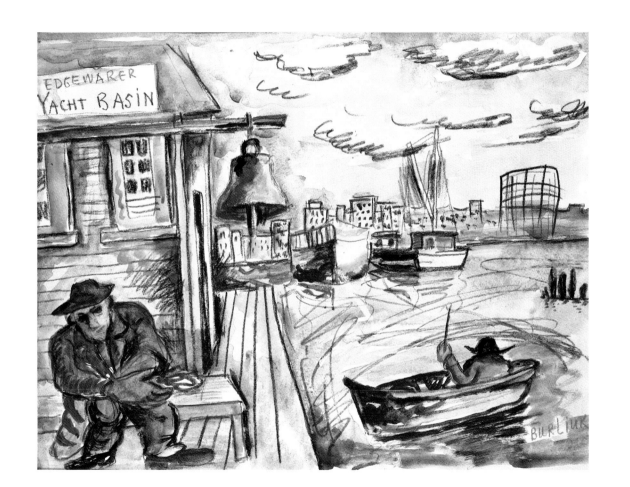

THEODORE EARL BUTLER (1861–1936)

11. *By Riverside*

Pastel on blue paper
12¼ × 19 inches
Signed lower right: T. E. Butler

Provenance:
Private Collection, Bridgeport, CT

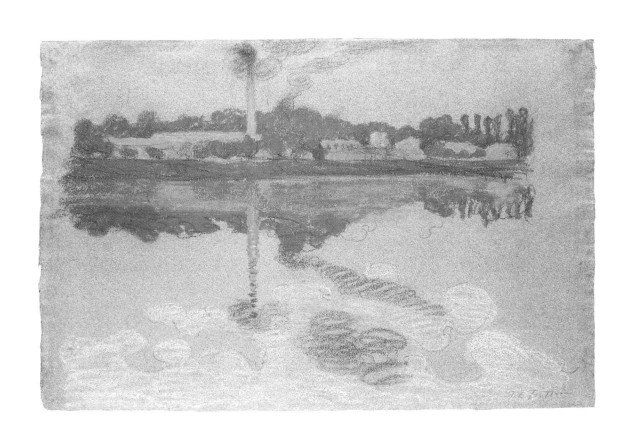

JAMES HENRY CAFFERTY (1819–1869)

12. *Vagabond at Rest*

Watercolor on paper
8¼ × 8¼ inches (tondo)
Signed and dated lower left: J. H. Cafferty April 1849

Provenance:
Private Collection, New York

Exhibited:
New York, NY, New-York Historical Society, *James Henry Cafferty, N.A. (1819–1869)*, May 22–August 24, 1986, Cat. No. 5.

Literature:
David Stewart Hull, *James Henry Cafferty, NA (1819–1869), A Catalogue Raisonné*, New-York Historical Society, NY, 1986, Cat. No. 4.

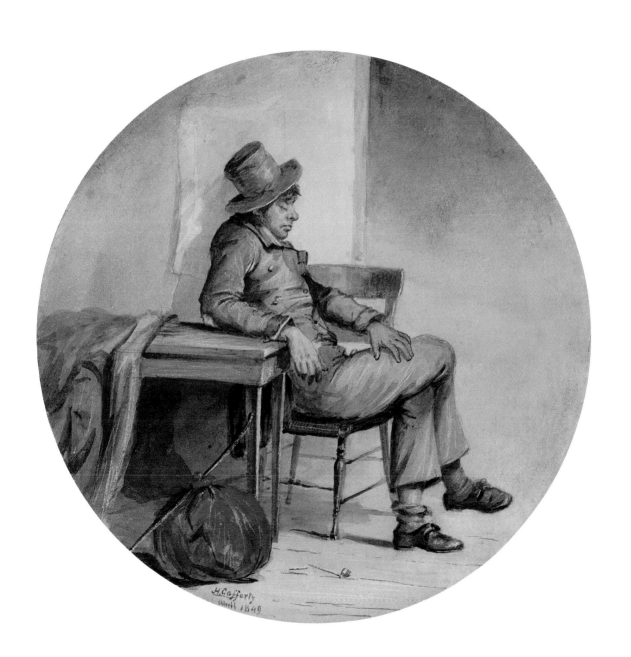

ALEXANDER STIRLING CALDER (1898–1976)

13. *Three Ring Circus*

India ink on paper
21⅞ × 15 inches
Signed and dated lower right: Calder 1932

Provenance:
Acquired directly from the artist
Jean Davenport Harris de Tomasi, Long Island, New York
Estate of Jean Davenport Harris de Tomasi, Long Island,
 New York

Note:
Jean Davenport Harris de Tomasi was an art student with
 Alexander Calder, and remained a close personal friend.

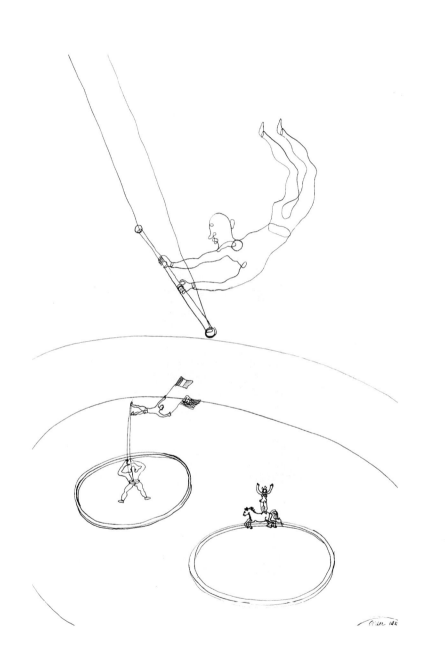

MARY CASSATT (1844–1926)

14. *Simone in an Armchair with Both Hands Resting on the Chair Arm*, Circa 1903

Pastel on paper
27 × 20 inches
Signed lower right: Mary Cassatt

Provenance:
Private Collection, Paris
Private Collection, Connecticut

Literature:
Adelyn Dohme, Breeskin, *Mary Cassatt: A Catalogue Raisonné*, illustrated no. 447, page 174.

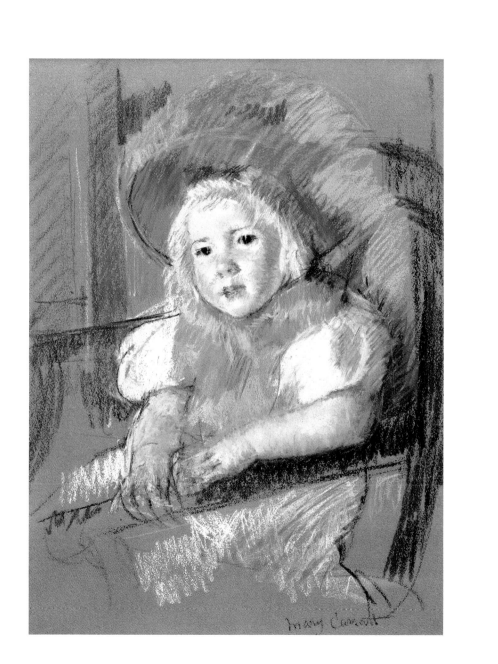

ELIOT CANDEE CLARK (1883–1980)

15. *New York, Central Park by the Mall*

Pastel on paper
8⅜ × 11 inches
Signed lower right: Eliot Clark

Provenance:
Estate of the artist
Mrs. Eliot Clark, the artist's wife

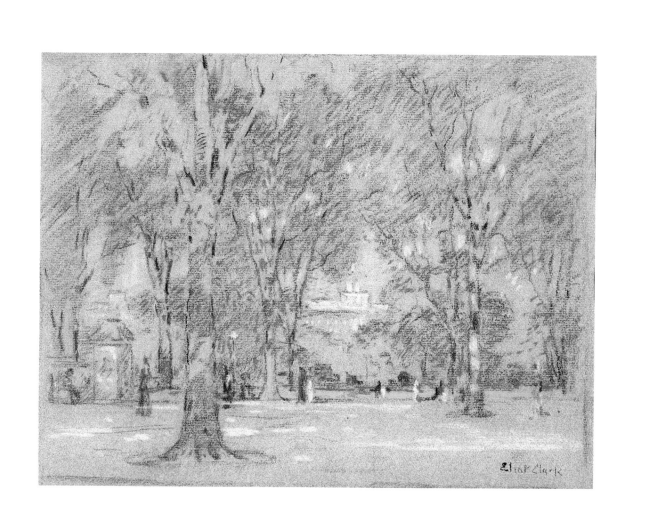

e e c u m m i n g s (1894–1962)

16. *Apache Dancers*

India ink on paper
15 × 10¾ inches

Provenance:
Estate of Scofield Thayer

This drawing was probably executed for *Dial*, an important
 magazine of the arts, in the 1920s and 30s. Scofield Thayer
 was one of the publishers of *Dial*.

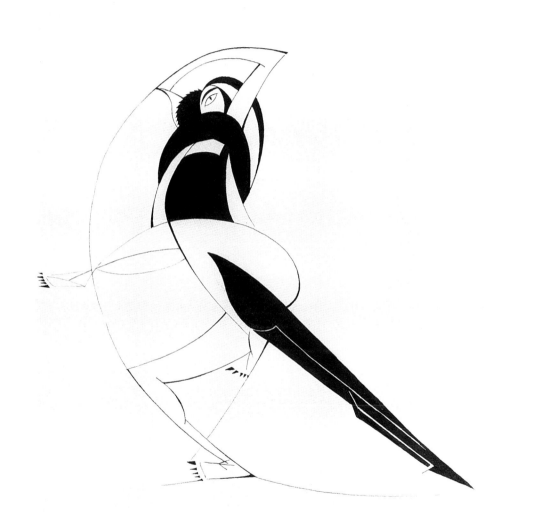

WILLEM DE KOONING (b. 1904)

17. *Two Women*, circa 1950s

Pastel on paper
21½ × 17½ inches
Signed lower right: de Kooning

Provenance:
Collection of Lloyd Goodrich
From the estate of Lloyd Goodrich

Exhibited:
New York, N.Y. The New School Art Center, *Museum Leaders
 Collect: Selections from the Private Collections of Ten New
 York Museum Directors and Curators.* April 24–May 27,
 1970, Cat. No. 19.

Literature:
*Museum Leaders Collect: Selections from the Private Collections
 of Ten New York Museum Directors and Curators,* New
 School Art Center, New York, 1970, p. 17, Cat. No. 19

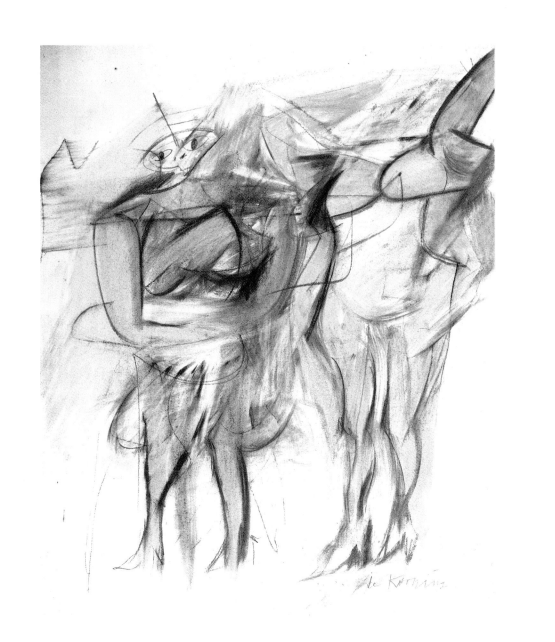

RAOUL MANCHERAT DE LONGPRE (Active Circa 1900)

18. *Lilacs and Yellow Roses*

Watercolor and gouache on board
28⅛ × 20⅞ inches
Signed lower right: R. M. de Longpre fils

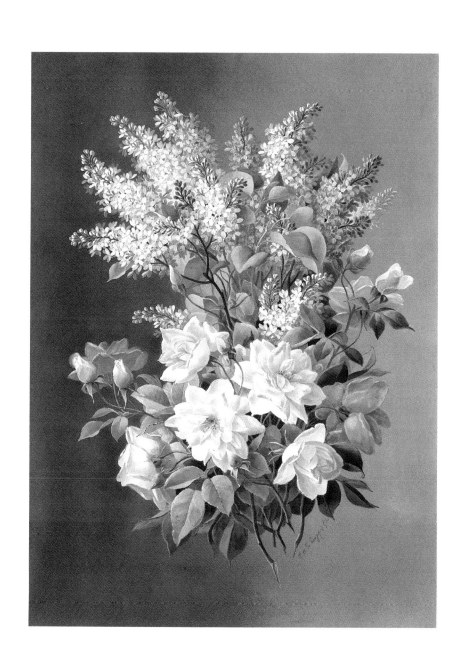

THOMAS WILMER DEWING (1851–1938)

19. *Woman in Blue Dress*

Pastel on board
10¼ × 7 inches
Signed lower right: T. W. Dewing

Provenance:
[Graham Gallery, New York]
JoAnn and Julian Ganz, Jr., Los Angeles, CA
Private Collection

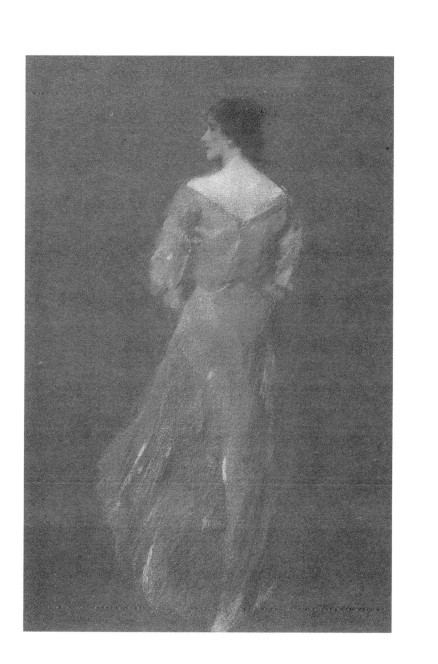

HENRY FARNY (1847–1916)

20. *Indian Hunters in the Snow*

Gouache on paper
8⅞ × 15½ inches
Signed and dated lower right: Farny/94

Provenance:
The artist
E. Arthur Dittman, Cincinnati, Ohio
By descent through the family to the present day

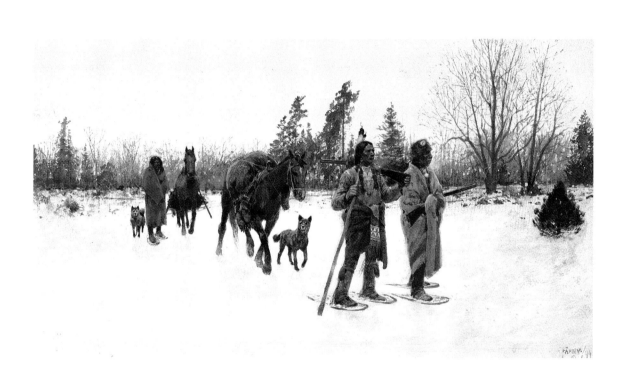

HENRY FARNY (1847–1916)

21. *Nest of Rattlesnakes*

Gouache on paper laid down on canvas
15 × 28 inches
Signed and dated lower right: H F Farny 94

Provenance:
[Clossons Art Gallery, Cincinnati, Ohio, in 1940]
Private Collection, Kentucky, 1940
By descent through the family to the present owner

Exhibited:
Spanierman Gallery, New York, *Masterworks of Henry Farny*,
 October 15–November 14, 1981, Cat. No. 12, p.8, illus-
 trated in color, n.p.

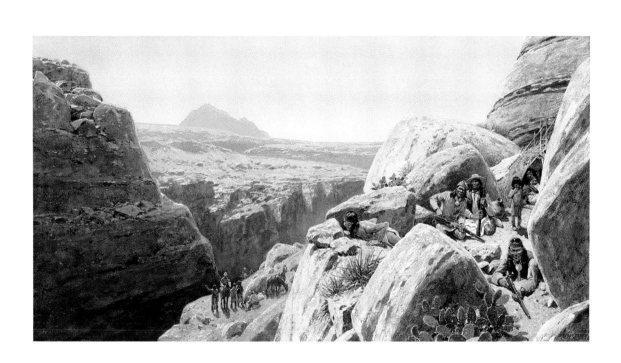

HENRY FARRER (1843–1903)

22. *Sunset Landscape with Pond*

Watercolor on paper
8 × 14 inches
Signed and dated lower left: H. Farrer 1886

Provenance:
Private Collection, Malibu, CA

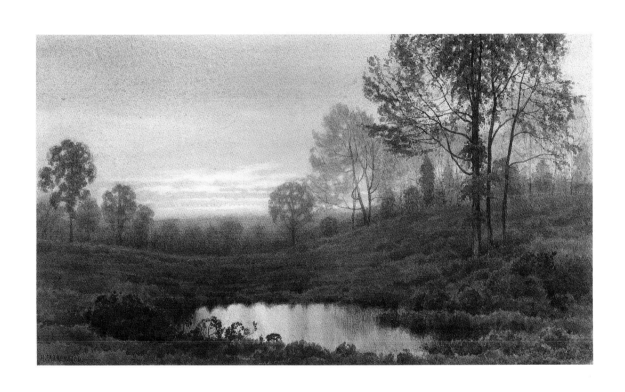

LYONEL FEININGER (1871–1956)

23. *Town Hall II*

India ink, gray wash and blue watercolor on paper
14¼ × 21⅞ inches
Signed lower left: Feininger
Inscribed with title lower center: Town Hall II
Dated lower right: 1939

Provenance:
Private Collection, New York State

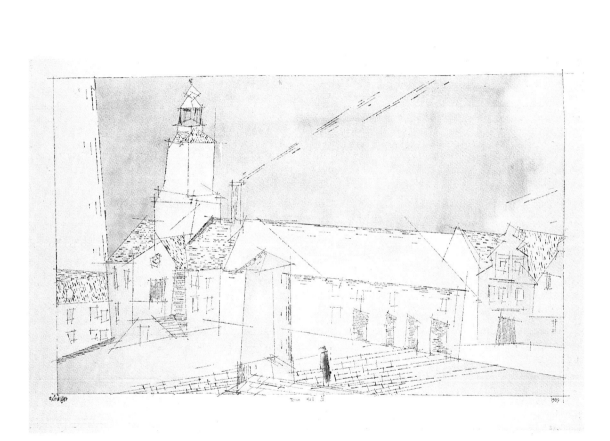

Town Hall

1929

ARTHUR CLIFTON GOODWIN (1864–1929)

24. *Promenade by the Charles, Boston*

Pastel on board
12¼ × 18¼ inches
Signed lower left: A. C. Goodwin

Provenance:
Private Collection, Rhode Island

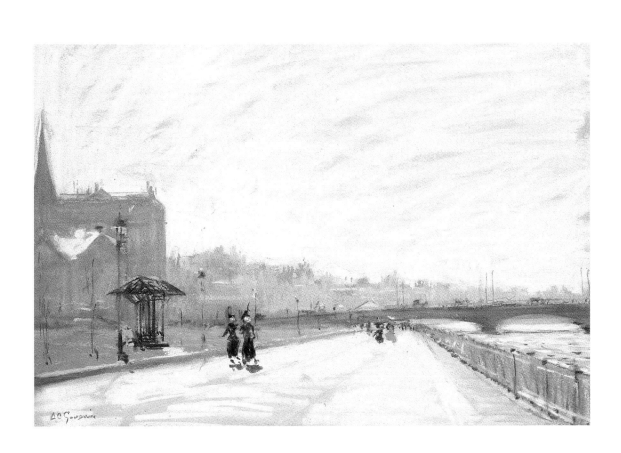

ARSHILE GORKY (1904–1948)

25. *Untitled*

Pastel and ink on paper
5¾ × 4½ inches
Inscribed on the reverse: Merry Xmas and love from Gorky
 (all 4 of them)

Provenance:
Gift of the artist
Julien Levy, New York, NY
Estate of Julien Levy

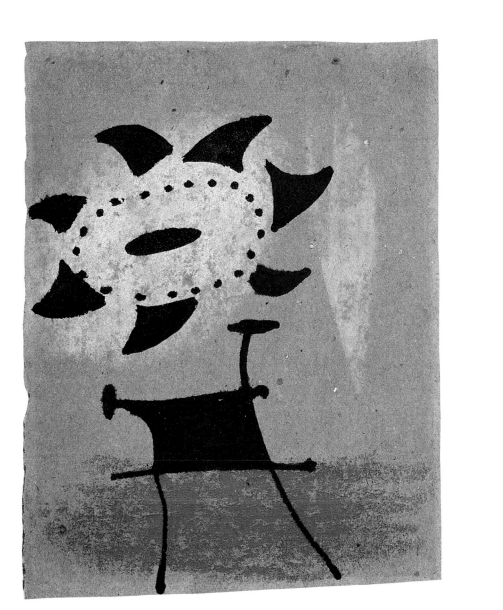

MORRIS GRAVES (b. 1910)

26. *Man Sleeping in Central Park*

Gouache on paper
15¾ × 18⅞ inches
Signed lower right: M. Graves
Inscribed on the reverse: Man Sleeping in Central Park
 (Night) 1937

Provenance:
[Paul Kantor Gallery, Los Angeles, CA]
Mr. and Mrs. Max Zurier
La Jolla Museum of Contemporary Art, La Jolla, CA

Exhibited:
Pasadena, CA, The Pasadena Museum of Art, *Mr. and Mrs.*
 Max Zurier Collection, April 30–May 21, 1963, Cat. No. 30

NANCY GROSSMAN (b. 1940)

27. *Gunhead #2*

Pencil on paper
19 × 24 inches
Signed and dated lower left: N. Grossman '73

Provenance:
[Cordier and Ekstrom, Inc., New York]
Private Collection, New York

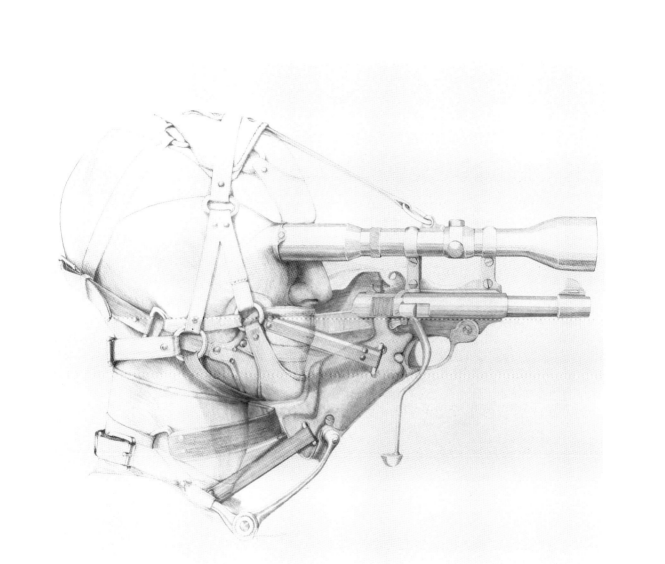

PHILIP LESLIE HALE (1865–1931)

28. *Woman in Repose*

Red and white chalk on paper
12 × 9 inches

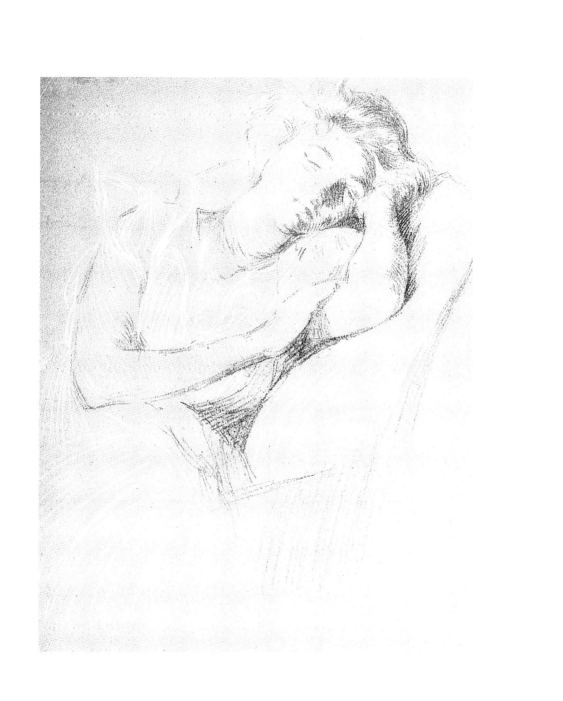

GEORGE HARVEY (Active 1835–1920)

29. *Black Boy Blowing Bubbles*

Watercolor and pencil on paper
16⅞ × 11⅛ inches
Signed and dated lower right: Geo. Harvey '87

Provenance:
Private Collection, New York

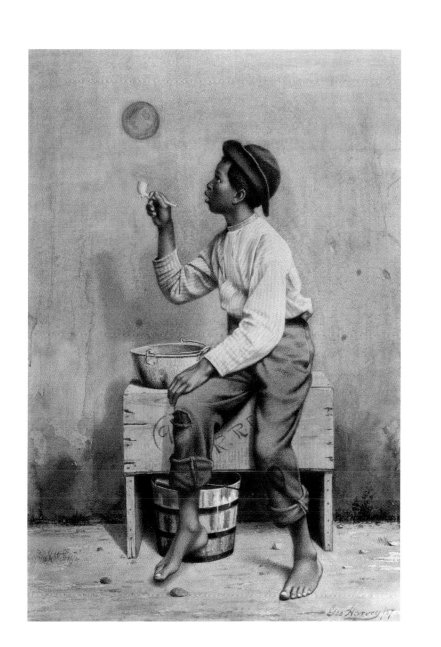

FREDERICK CHILDE HASSAM (1859–1935)

30. *Beached Boats*, Circa 1885

Watercolor on paper
12 × 20 inches
Signed lower right: Childe Hassam
Beard date: '07

Provenance:
L. Lombard-Buckner
[Wildenstein and Co., New York]
[Gallery Reese Palley, Atlantic City, NJ]
Private Collection

Note:
This watercolor will be included in Stuart P. Feld and
 Kathleen M. Burnside's catalogue raisonné of Hassam's
 work.

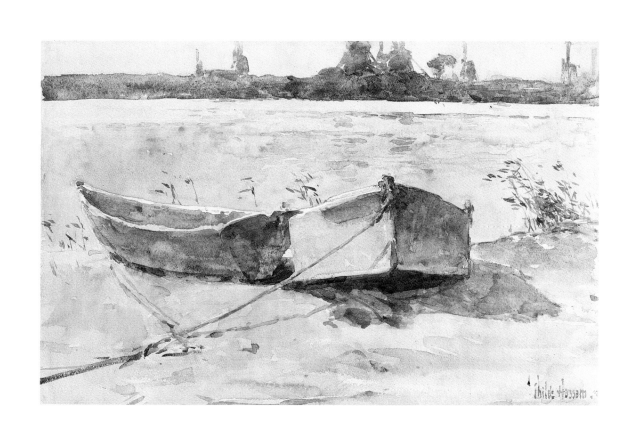

FREDERICK CHILDE HASSAM (1859–1935)

31. *Lafayette Park, Washington, DC*

Watercolor and pencil on paper
9 × 11¼ inches
Signed, dated and inscribed lower left: Childe Hassam
 Washington March 26, 1926
Inscribed verso: Lafayette Park, Washington, DC

Provenance:
Private Collection, California

Note:
This watercolor will be included in Stuart P. Feld and
 Kathleen M. Burnside's catalogue raisonné of Hassam's
 work.

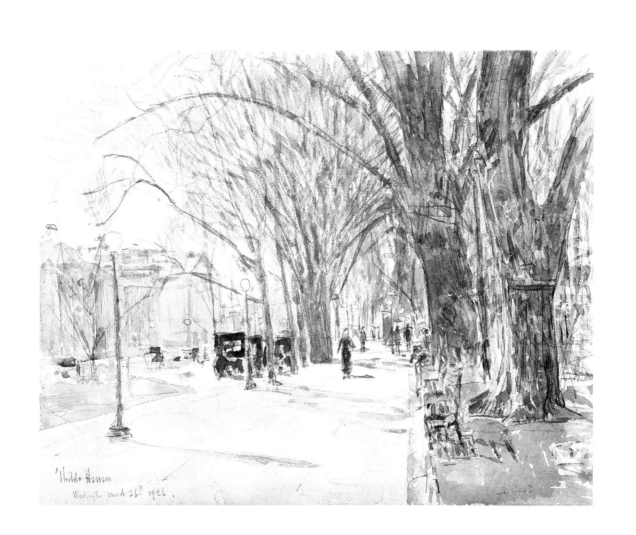

'Childe Hassam
Washington March 26th 1926.

HUGHSON HAWLEY (1850–1936)

32. *Farm in Poughkeepsie*

Watercolor on paper
12 × 29 inches
Signed lower right: Hughson Hawley
Inscribed on the reverse: In Poughkeepsie

JOHN WILLIAM HILL (1812–1879)

33. *Golden Afternoon*

Watercolor on paper
12½ × 18 inches
Signed lower right: J. W. Hill

Provenance:
Private Collection

CLARENCE KEISER HINKLE (1880–1900)

34. *Santa Barbara Landscape Looking to Mountains*

Watercolor on paper
13 × 20½ inches
Signed lower center: Hinkle
Signed again on the reverse: Clarence Hinkle
Inscribed with title on a label

Provenance:
Estate of the artist
Westmont College, Santa Barbara, CA

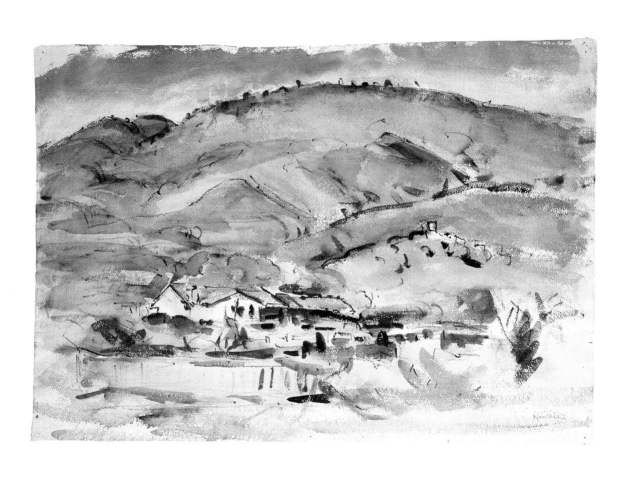

CARL ROBERT HOLTY (1900–1973)

35. *Abstraction*

Watercolor on board
12 × 18 inches
Signed lower right by the artist's wife: Carl Holty EH 1936

Provenance:
Estate of the artist
The artist's wife
Private Collection, New York, NY

Exhibited:
New York, NY, Riverside Museum, n.d.

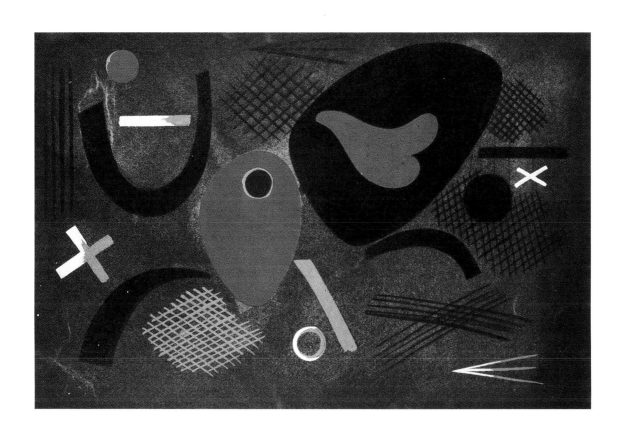

WINSLOW HOMER (1836–1910)

36. *Woman with a Black Hat*, Circa 1880

Watercolor over pencil on paper
9 × 13 inches
Inscribed on reverse: Painted and presented by Winslow
 Homer to me as a wedding gift–May 19th 1880. Josephine
 M. Hamline

Provenance:
Gift of the artist to Josephine Meade Hamline, Lake Forest, IL
By descent to her daughter, Mrs. Uri Grannis, Lake Forest, IL
By descent to her daughter, Mrs. Donald J. Ford, Lake
 Forest, IL
Mr. Duane B. Garrett, Tiburon, CA
James K. Devlin Separate Property Trust, Dallas, TX
[Spanierman Gallery, New York]
Private Collection, CT

Note:
This watercolor will be included in the CUNY/Goodrich/
 Whitney catalogue raisonné of Winslow Homer's work.

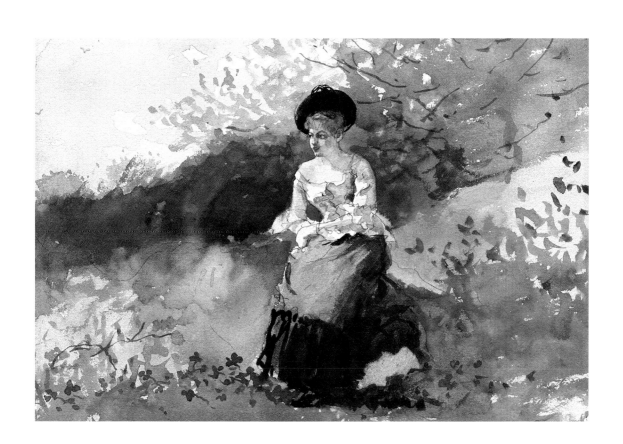

EDWARD HOPPER (1882–1967)

37. *Vermont Hillside*, 1936

Watercolor on paper
20⅛ × 27⅞ inches
Signed lower right: Edward Hopper

Provenance:
The Artist
[Frank Rehn Gallery]
Collection of Lloyd Goodrich, 1947
From the estate of Lloyd Goodrich

Exhibited:
Brooklyn, NY, The Brooklyn Museum, *Ninth Biennial:*
International Exhibition of Water Colors, May 8–June 12,
1937.
Toledo, OH, Toledo Museum of Art, *Exhibition of American*
Watercolors, October 2–30, 1938, Cat. No. 52.
Philadelphia, PA, Pennsylvania Academy of the Fine Arts,
The Thirty-Eighth Annual Philadelphia Water Color and
Print Exhibition and the Thirty-Ninth Exhibition of Minia-
tures, November 3–December 8, 1940, Cat. No. 392.
New York, NY, Whitney Museum of Art, *Edward Hopper*
Retrospective Exhibition, February 11–March 26, 1950,
Cat. No. 116.
Manchester, NH, The Currier Gallery of Art, *Watercolors by*
Edward Hopper with a Selection of His Etchings, October
8–November 15, 1958, Cat. No. 33.
Clinton, NY, The Edward W. Root Art Center, Hamilton
College, *Edward Hopper: Oils, Watercolors, Prints*, May
10–June 7, 1904, Cat. No. 23.
New York, NY, Whitney Museum of American Art, *Edward*
Hopper, September 30–November 29, 1964, Cat. No. 119.

Literature:
Listed in record books kept by Jo Hopper (the artist's wife).
Lloyd Goodrich, *Edward Hopper*, New York, Harry N.
Abrams, 1978, illustrated p. 235.

Note:
This work is to be published in Gail Levin's forthcoming
Edward Hopper: A Catalogue Raisonné.

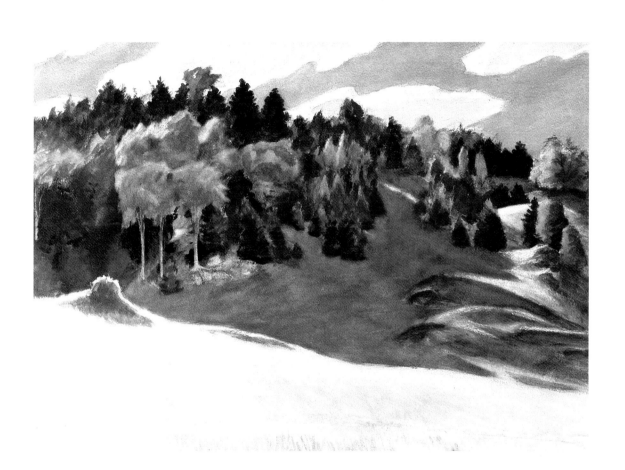

EDWARD HOPPER (1882–1967)

38. *Shacks at Pamet Head*, (Massachusetts), 1937

Watercolor on paper
20 × 22 inches
Signed lower right: Edward Hopper

Provenance:
The artist
Collection of Lloyd Goodrich, 1950
From the estate of Lloyd Goodrich

Exhibited:
Philadelphia, PA, The Pennsylvania Academy of the Fine
 Arts, *The Thirty-Eighth Annual Philadelphia Water Color
 and Print Exhibition and the Thirty-Ninth Annual Exhibi-
 tion of Miniatures*, November 3–December 8, 1940, Cat.
 No. 400.
New York, NY, Whitney Museum of American Art, *Edward
 Hopper Retrospective Exhibition*, February 11–March 26,
 1950, Cat. No. 118. Exhibit traveled to the Museum of Fine
 Arts, Boston, MA and The Detroit Institute of Arts, Detroit,
 MI.
New York, NY, Whitney Museum of American Art, *Edward
 Hopper*, September 30–November 29, 1964, Cat. No. 121.
New York, NY, New School Art Center, *Museum Leaders
 Collect: Selections from Private Collections of Ten New
 York Museum Directors and Curators*, April 24–May 27,
 1970, Cat. No. 19.

Literature:
Listed in the record books kept by Jo Hopper (the artist's
 wife).
Lloyd Goodrich, "*Portrait of the Artist*", *Woman's Day* 29,
 (February 1965), illustrated p. 38.
Lloyd Goodrich, *Edward Hopper*, New York, Harry N.
 Abrams, 1978, illustrated p. 240.

Note:
This work is to be published in Gail Levin's forthcoming
 Edward Hopper: A Catalogue Raisonné.

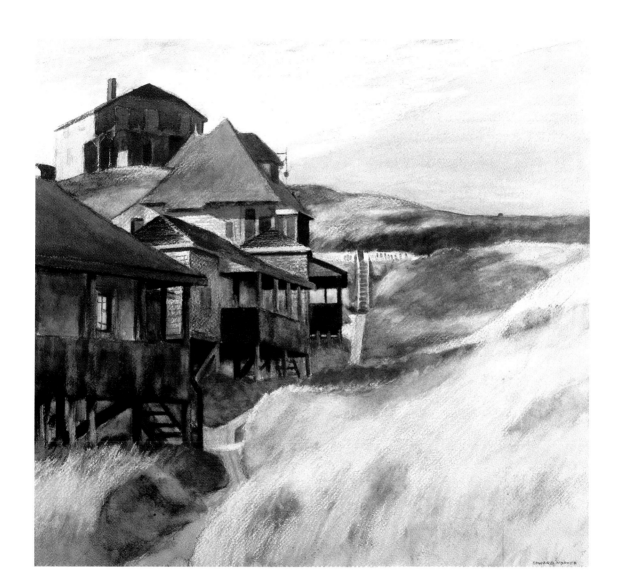

ALFRED CORNELIUS HOWLAND (1838–1909)

39. *Woman with a Jug*

Pencil and white chalk on paper
9¾ × 7½ inches
Signed with initials and inscribed, lower left: ACH Stafford

Provenance:
[Coe Kerr Gallery, Inc.]
Private Collection, Pittsburgh, PA

Literature:
William H. Gerdts, *Alfred Cornelius Howland 1838–1909*,
 (exhibition catalogue, Coe Kerr Gallery), New York, 1971

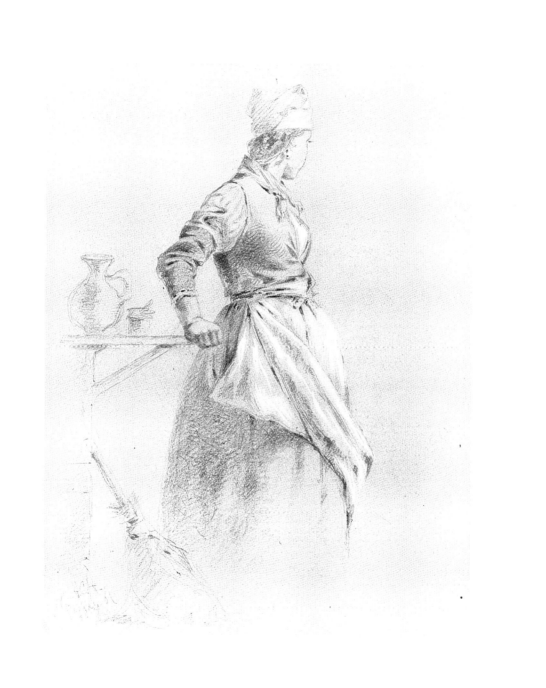

DAVID JOHNSON (1827–1908)

40. *Poplar, Joyceville Connecticut*

Pencil and Chinese white on grey paper
11½ x 17¾ inches
Signed with initials and dated lower right: DJ 81
Inscribed lower right: Poplar/Joyceville/No. 37

Exhibited:
Yonkers, NY, The Hudson River Museum of Westchester,
 Meditations on Nature: The Drawings of David Johnson,
 February 28–June 19, 1988, Cat. No. 45, illustrated p. 74.

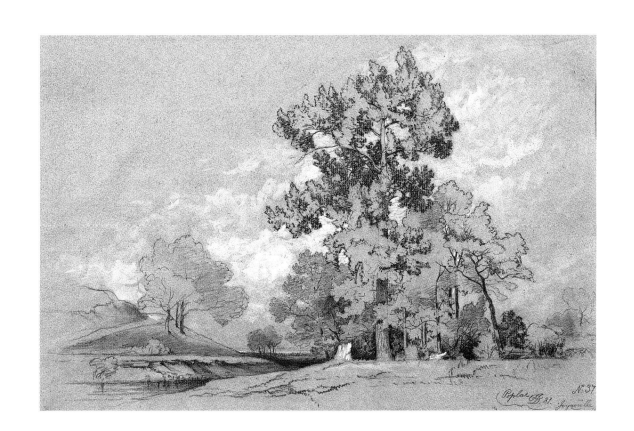

Poplar *G 81.* N° 37
 Serpentin

RAYMOND JONSON (1891–1982)

41. *Watercolor #6*

Watercolor and airbrush on board
27 × 23 inches
Signed and dated lower center: Jonson 44
Signed again, dated and inscribed on the reverse: Raymond
 Jonson/Watercolor No. 6—1944/1–30–44 and with palette
 information.

Provenance:
Acquired directly from the artist
By descent in the family

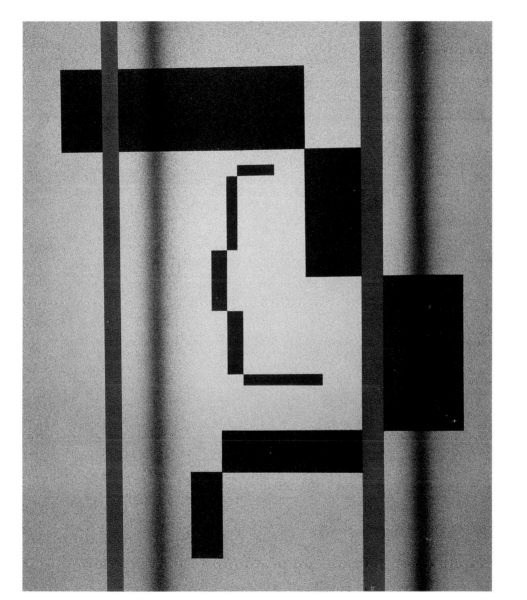

CHARLES SALIS KAELIN (1858–1929)

42. *Woodland Path with Rock*

Pastel on paper
16 × 14 inches
Signed lower left: C. S. Kaelin

Provenance:
Estate of the artist

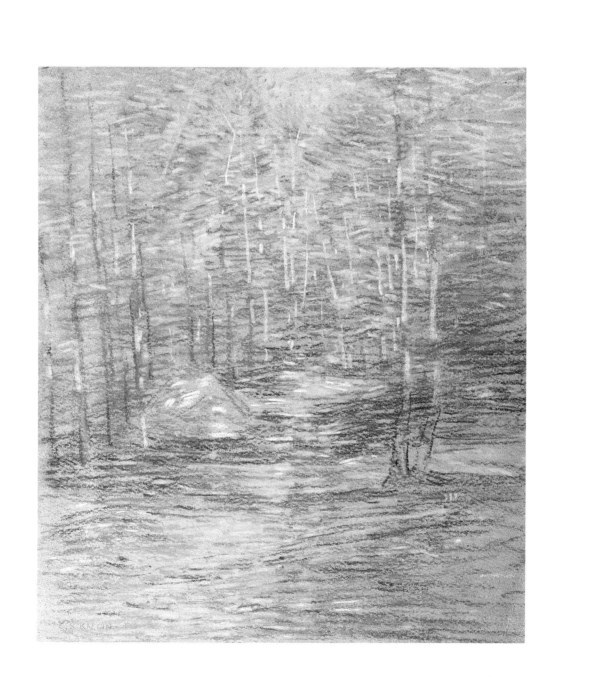

HENRY GEORGE KELLER (1870–1949)

43. *The Venetian Canal*

Watercolor on paper
19½ × 13 inches
Signed and dated lower left: H. G. Keller Venice '02

Provenance:
Private Collection, Shaker Heights, OH

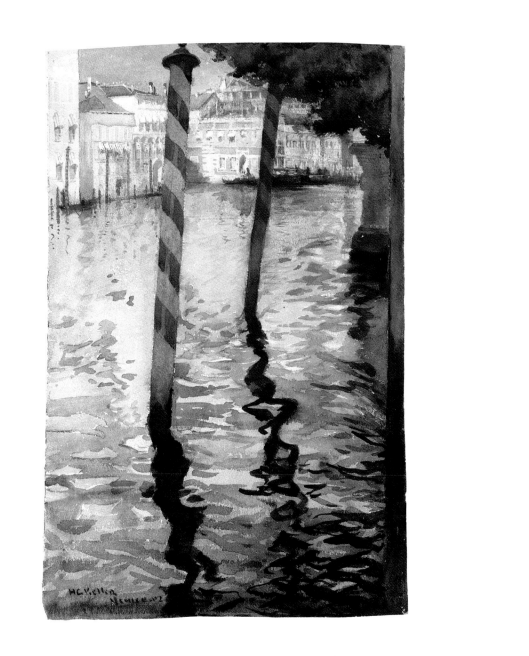

AUGUSTUS KOLLNER (1813–1906)

44. *The Bedford Springs Hotel*

Pen and sepia ink on paper
8 × 10½ inches
Inscribed with title, lower left
Dated lower right: July 1840

Provenance:
An East Coast Museum

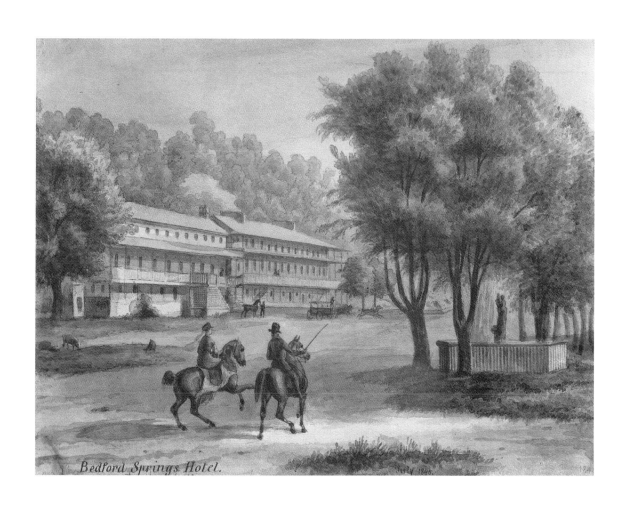

Bedford Springs Hotel.

YASUO KUNIYOSHI (1893–1953)

45. *Country Road*

Pen and ink on paper
12 × 9½ inches
Signed and dated lower right: Kuniyoshi 21

Provenance:
Private Collection, New York State

Exhibited:
New York, NY, The Daniel Gallery, 1922

Literature:
William Murrell, *Yasuo Kuniyoshi*, William M. Fisher,
 Woodstock, New York, 1922.

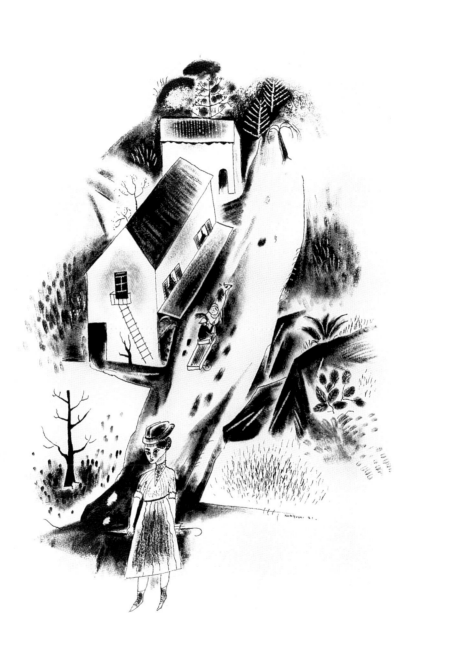

RICHARD HAYLEY LEVER (1876–1958)

46. *Misty Morning, Gloucester*

Watercolor and black crayon on paper
18¾ × 22¾ inches
Signed and initialed lower right: Hayley Lever HL

Provenance:
Estate of the artist
[Clayton-Liberator Gallery, Long Island, New York]
Private Collection, New York

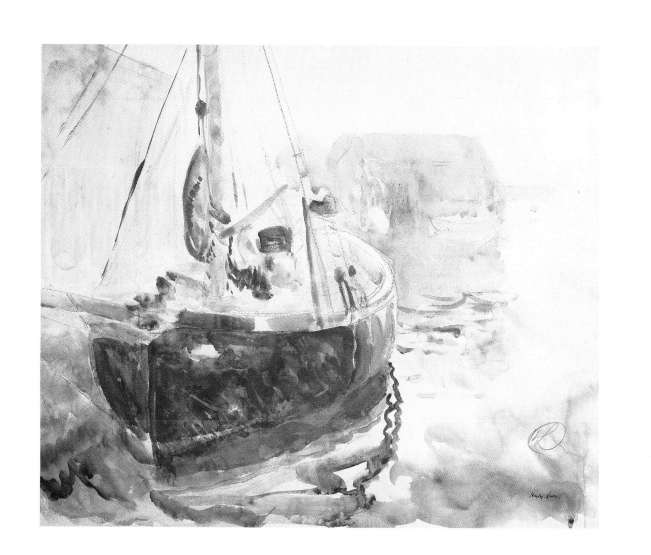

CONRAD MARCA-RELLI (Born 1913)

47. *Figure Study*

Brown ink on tan paper
8¾ × 7¾ inches
Signed and dated lower left: Marca-Relli 55

Provenance:
[Dayton's Gallery 12, Minneapolis, MN]
Paul Magriel, New York, NY
Private Collection, New England

Exhibited:
Austin, TX, University of Texas, University Art Museum;
 Youngstown, OH, Butler Institute of American Art; *The
 Paul Magriel Collection of American Drawing*, October-
 November 1962, Cat. No. 69.

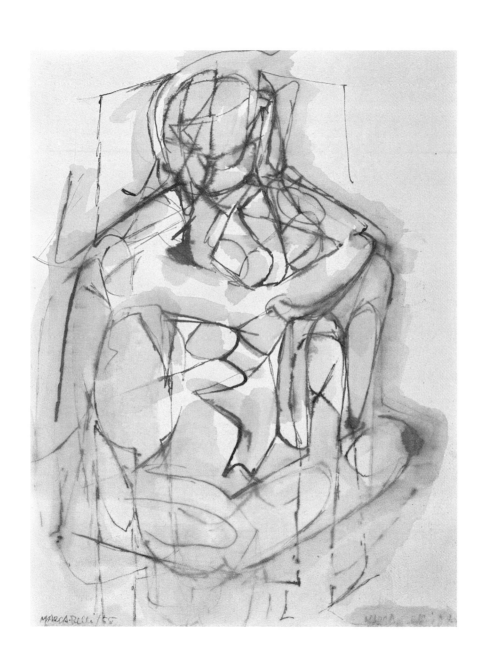

MARCA-RELLI/55

REGINALD MARSH (1898–1954)

48. *Freight Train*

Watercolor on board
15¾ × 21¾ inches
Signed and dated lower right: Reginald Marsh 1929

Provenance:
Collection of Lloyd Goodrich, New York, NY
From the estate of Lloyd Goodrich

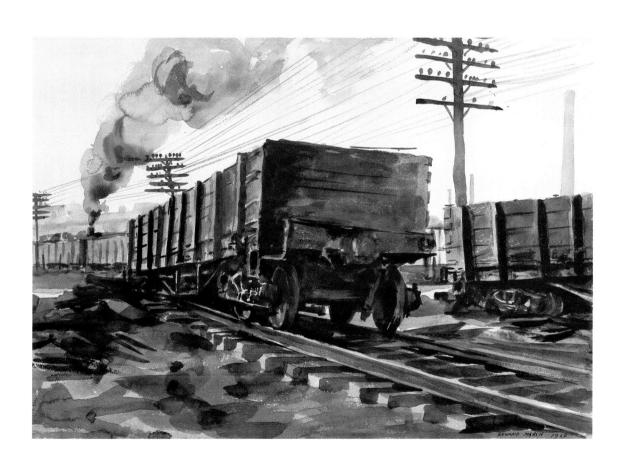

FLETCHER MARTIN (1904–1979)

49. *The Brown Bomber*

Pencil on paper
22 × 17 inches
Signed and dated lower right: Fletcher Martin '37

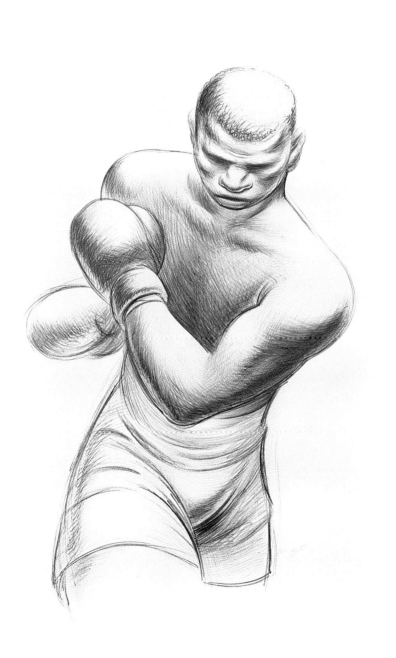

HENRY BAINBRIDGE MC CARTER
(1866–1942)

50. *View through the Trees*

Pastel on paper
20 × 26 inches
Signed and dated lower left: Henry McCarter 33

Provenance:
Private Collection, New York

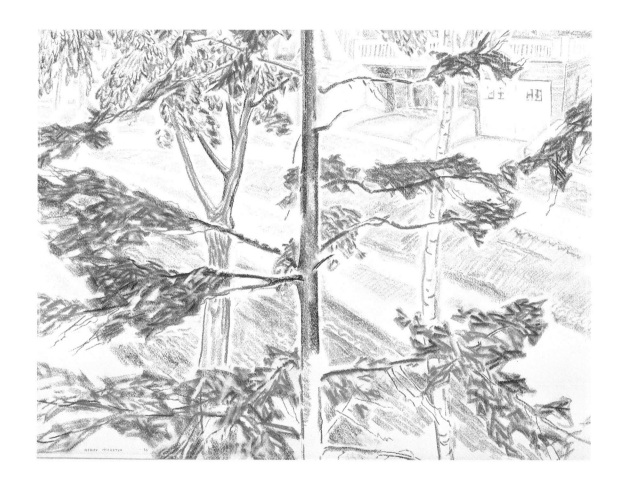

JOHN FRANCIS MURPHY (1853–1921)

51. *Bellona*

Pencil on paper
14 × 11 inches
Inscribed and dated lower left: Bellona 9'9'81

Provenance:
Estate of the artist
American Art Association, Inc., New York, November 26,
 1926, No. 162
Private Collection

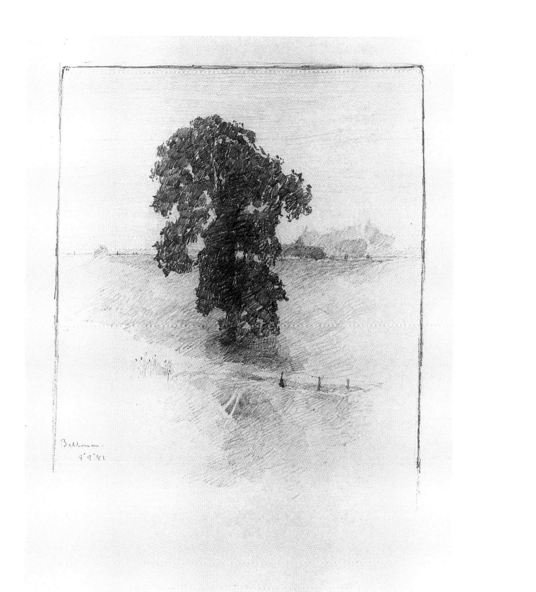

Bellman.
9'9'81

ELIZABETH NOURSE (1859–1938)

52. *Study for "La Veilee"*

Charcoal and pastel on paper
54 × 40½ inches
Signed and dated lower left: E. Nourse '98

Provenance:
Mrs. Hammond, Evanston, IL (until 1912)
Private Collection
Private Collection, Cincinnati, OH

Exhibited:
Paris, New Salon, 1899, Cat. No. 1974.
Chicago, IL, Chicago Watercolor Society, 1912, Cat. No. 167.

Literature:
Chicago Tribune, May 11, 1912 (illustrated).
M.A.H. Burke, *Elizabeth Nourse, 1859–1938, A Salon
 Career*, Washington, DC, 1983, P. 170, Cat. No. A-43

Note:
This work has undergone extensive restoration. A conser-
 vator's report is available.

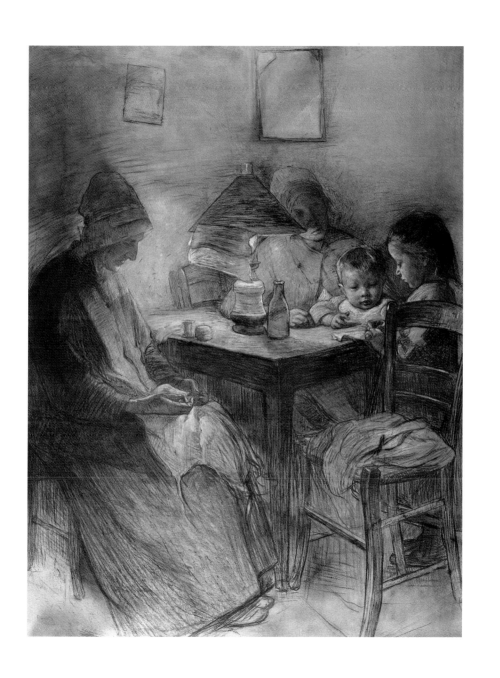

JULES PASCIN (1885–1930)

53. *Les Soeurs*

Pencil on paper
25 × 19 inches
Signed lower right: Pascin

Provenance:
[Perls Galleries, New York, NY]
Robert Laurent, New York, NY
Private Collection, New York

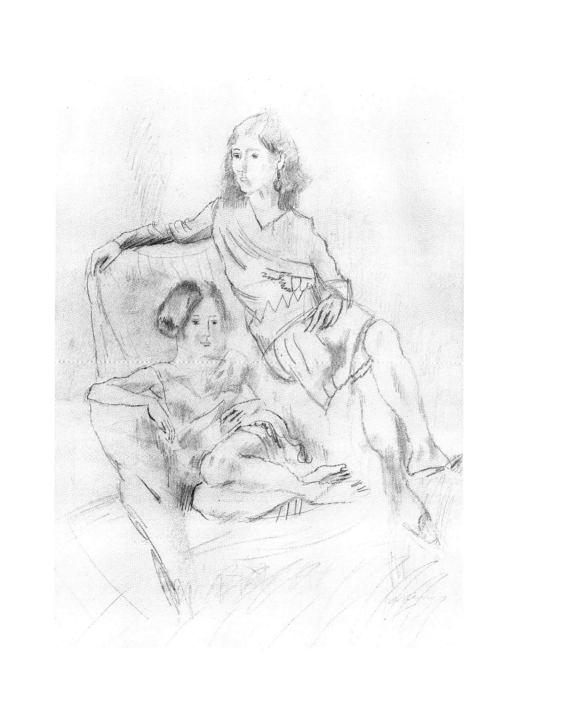

OGDEN MINTON PLEISSNER (1905–1983)

54. *The Courtyard, Fontainebleau*

Watercolor over pencil on paper
19⅜ × 29¼ inches
Signed lower left: Pleissner

Provenance:
[Milch Galleries, New York]
Private Collection

Exhibited:
New York, NY. National Academy of Design, *American Watercolor Society, Annual Exhibition*, 1957.

EDWARD HENRY POTTHAST (1857–1927)

55. *Figures by the Beach Under Umbrellas*

Pencil and blue crayon
5 × 8 inches
Verso: *Seated Figures Reading*

Provenance:
Private Collection, Cincinnati, Ohio

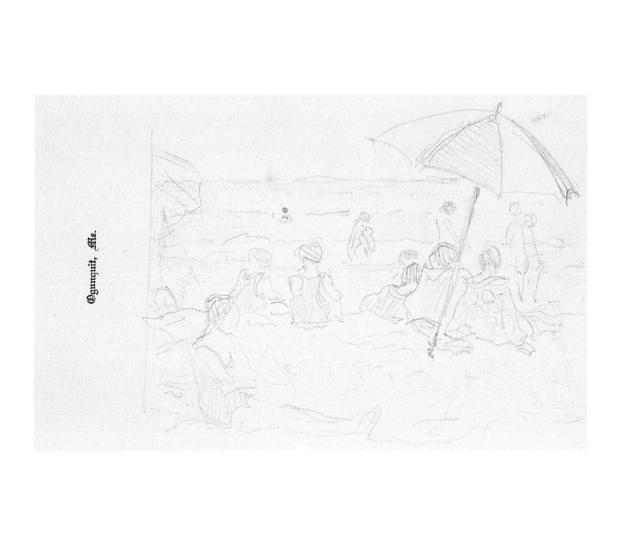

Ogunquit, Me.

MAURICE BRAZIL PRENDERGAST
(1858–1924)

56. *A Sketchbook*, Circa 1917

Various media on paper: Watercolor and pencil (12 pages),
Pencil (42 pages), Crayon (3 pages)
Sheet size: 8¾ × 5¼ inches
Some sheets bear inscriptions

Provenance:
The artist
Estate of the artist
Charles Prendergast, the artist's brother
Mrs. Charles Prendergast (until circa 1970)
Private Collection, Philadelphia, PA

The only known fully-bound sketchbook by Maurice
Prendergast still available. This extraordinary work depicts
brilliantly colored watercolors and studies of daily life in
the 1900's. Harbor views, village rooftops, children with
boats and the Boston Public Garden are here depicted by
the artist.

Of the other eighty-nine Prendergast sketchbooks, seventy-
five are held by the Museum of Fine Arts, Boston, and five
are in the Williams College Museum of Art. The John Sloan
Study Collection at the Delaware Art Museum and the
Wadsworth Atheneum, Hartford, Connecticut each have
one example. The Cleveland Museum has four sketchbooks
and the Metropolitan Museum of Art, New York has two.

Note:
This sketchbook will be included in the forthcoming catalogue
raisonne of Maurice Prendergast's work being compiled
at the Williams College Museum of Art, Williamstown, MA.

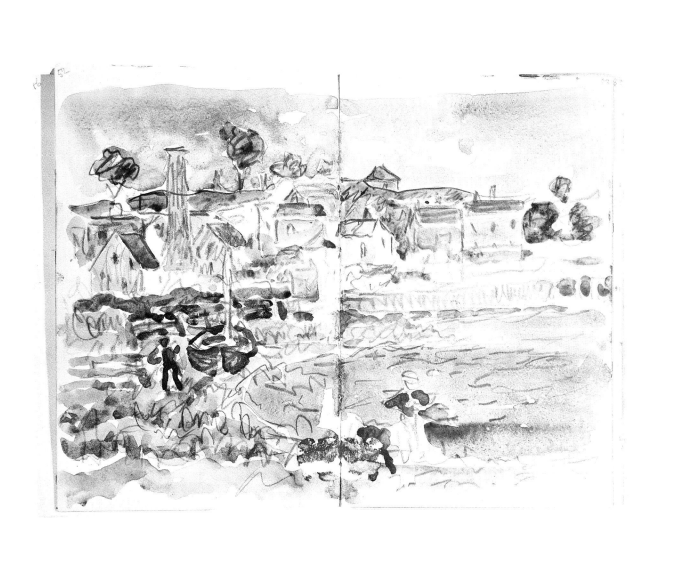

WILLIAM TROST RICHARDS (1833–1905)

57. *Easton's Pond, Newport, Rhode Island*

Watercolor on paper
5¼ × 13 inches
Inscribed on the verso: Easton's Pond, Newport, RI, 1874
 Edith Ballinger Price, granddaughter of the artist

Provenance:
By descent in the artist's family
Edith Ballinger Price, the artist's granddaughter
Private Collection, Washington, D.C.

JOHN SINGER SARGENT (1856–1925)

58. *The Portal of S. Giorgio Maggiore, Venice*, Circa 1903

Watercolor over pencil on paper
9½ × 13¾ inches
Signed lower right: John S. Sargent

Provenance:
Mrs. Seymour Trower, London, UK (until 1921)
Coal Thomson, Barbizon House, London, UK
[M. Knoedler & Co., New York (until 1924)]
Joseph A. Skinner, South Hadley, Massachusetts (until
 1965)
By descent to Elisabeth H. Skinner, South Hadley, Massachu-
 setts (until 1988)
Estate of Elisabeth H. Skinner, South Hadley, Massachusetts

Exhibited:
London, Barbizon House, Royal Society of Painters in
 Watercolors, 1924, Number 1594
Holyoke, MA, Holyoke Museum, 1946.

Note:
This watercolor will be included in the forthcoming cata-
 logue raisonné, *John Singer Sargent*, by Richard Ormond,
 Warren Adelson, Donna Seldin and Odile Duff.

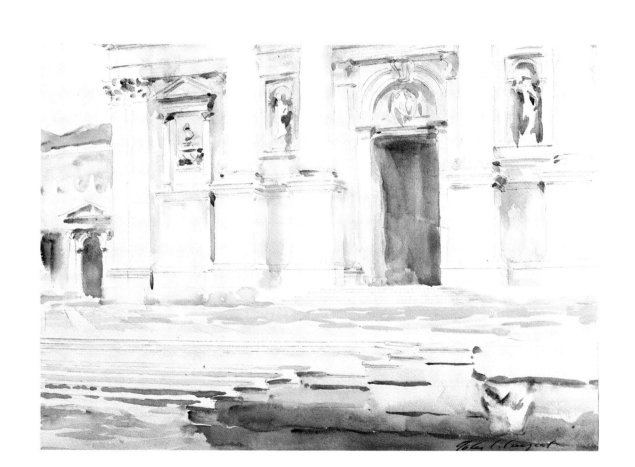

AARON DRAPER SHATTUCK (1832–1928)

59. *Bellows Falls, October 1861*

Pencil on paper
12½ × 19¼ inches
Inscribed with title, date and color notations, lower right

FRANCIS AUGUSTUS SILVA (1835–1886)

60. *Crashing Surf*

Watercolor on paper
11¼ × 26½ inches
Signed and dated lower right: F.A. Silva 1883

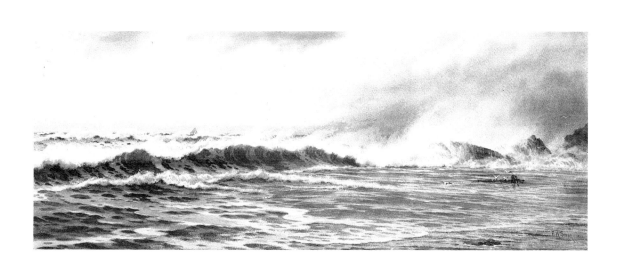

JOHN SLOAN (1871–1951)

61. *Girl Dressing*

Conte on paper
11¾ × 9½ inches
Signed by the artist's wife, lower left: John Sloan, 1914, HFS

Provenance:
Estate of the artist
Helen Farr Sloan, the artist's wife
[Gallery 52, South Orange, NJ]
Private Collection

Note:
This drawing is included in the inventory of John Sloan's
 work as number 1012 and will be included in the catalogue
 raisonné of Sloan's work being compiled by Mrs. Helen Farr
 Sloan and Rowland Elzea at the Delaware Art Museum.

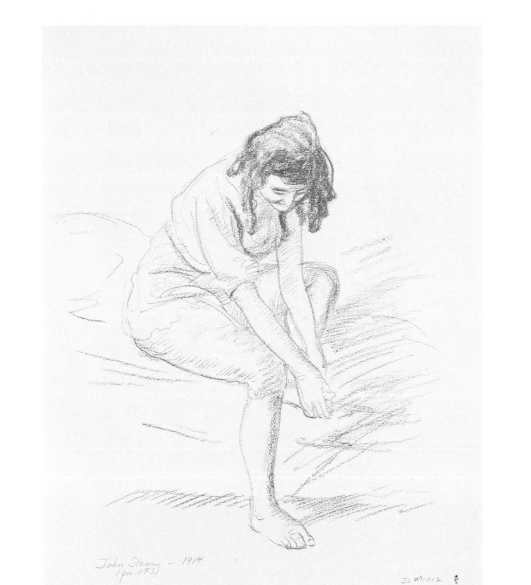

John Sloan — 1914
(per #7.3)

Girl Dressing

JS #⅟₁₀₁₂

WALTER GRANVILLE SMITH (1870–1938)

62. *Along the Beach, Bellport Bay, New York*

Watercolor on paper
9¾ × 12½ inches
Signed lower left: W. Granville Smith

Provenance:
Private Collection, Bellport, New York

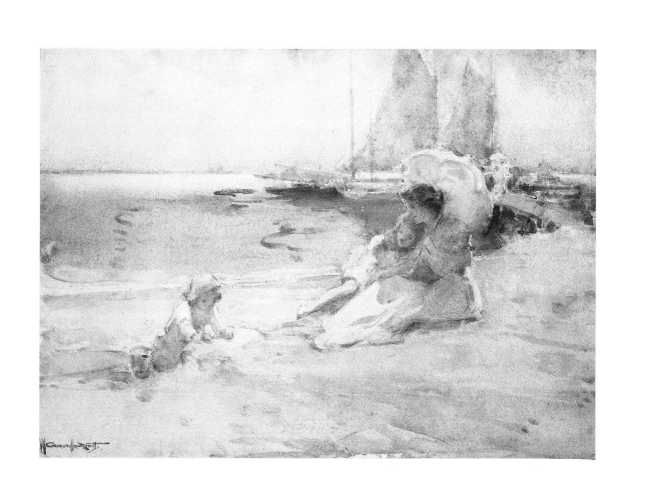

EUGENE SPEICHER (1883–1962)

63. *Standing Nude*

Pencil on paper
17⅛ × 9¾ inches
Signed lower right: Eugene Speicher

Provenance:
Estate of Amaylia Castaldo Trebilcock

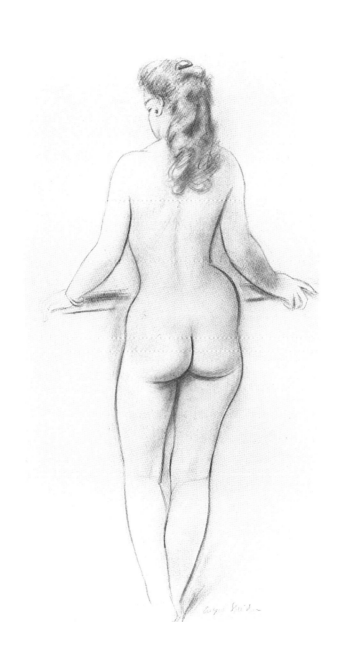

JOSEPH STELLA (1877–1946)

64. *White Iris*

Silverpoint and colored pencils on paper
13⅛ × 10½ inches
Signed lower right: Joseph Stella

Provenance:
Estate of the artist
[Rabin and Krueger Gallery, Newark, NJ]
Estate of Elizabeth Rosenstein

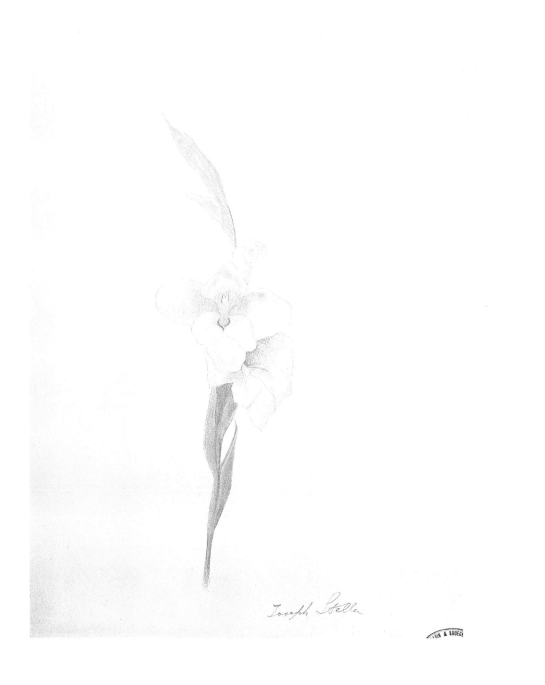

Joseph Stella

FLORINE STETTHEIMER (1871–1944)

65. *Midsummer Bouquet*

Watercolor on paper
15 × 19½ inches
Signed in petals: Florine to Fania

Provenance:
Fania Marinoff, wife of Carl Van Vechten
Mr. Carl Van Vechten, Fania Marinoff's husband
Mr. Mark Lutz (given to him by Mr. Van Vechten)
Mr. William Jepson (willed to him by Mr. Lutz)
Dr. George P. Glauner, Rosemont, Pennsylvania (willed to
 him by Mr. Jepson)

Note:
This watercolor is to be included in Barbara Bloemink's
 forthcoming catalogue raisonné of Florine Stettheimer's
 work.

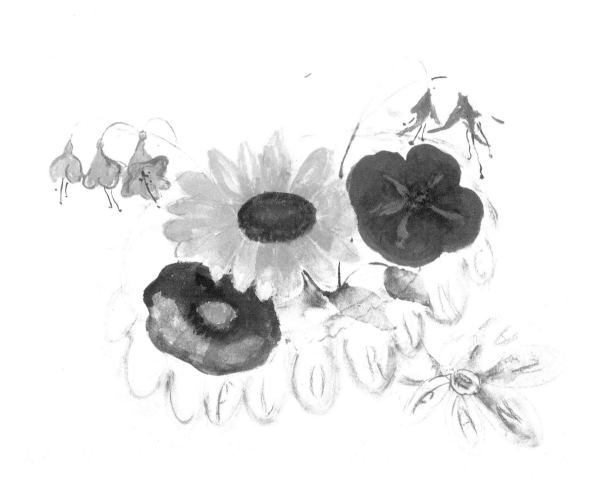

JOHN HENRY TWACHTMAN (1853–1902)

66. *The Ledges*, Circa 1888–1889

Pastel on pumice board
8¾ × 13 inches
Signed lower left: J H Twachtman

Provenance:
[William Macbeth, Inc., New York]
Private Collection, New York State
By descent in the family

Exhibited:
New York, NY, William Macbeth, Inc., *Summer Exhibition*,
 1927, Cat. No. 18
New York, NY, Anderson Galleries, *Exhibition of Works by
 American Artists Selected by the Associated Dealers in
 American Paintings, Inc.*, February 21-March 10, 1928,
 Cat. No. 198.

NOTE:
This pastel will be included in Ira Spanierman and Lisa N.
 Peters' forthcoming catalogue raisonné of the artist's work.

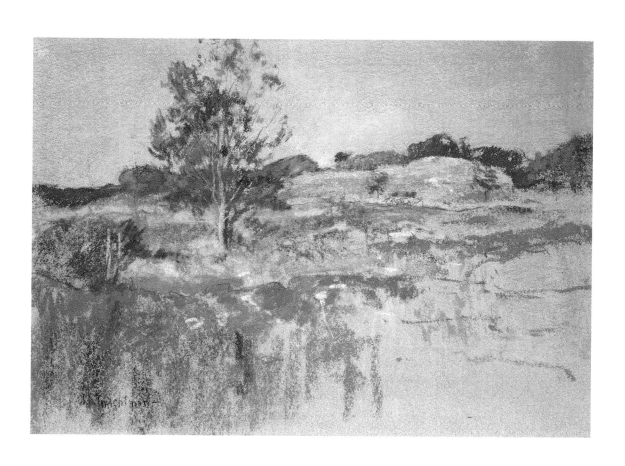

ELIHU VEDDER (1836–1923)

67. *Roadside Figure with Umbrella*

Pastel on paper
15 × 24½ inches
Signed lower right: Vedder

Provenance:
Estate of the artist
Miss Anita Vedder, St. Augustine, Florida, the artist's
 daughter
St. Augustine Historical Society Library, St. Augustine,
 Florida

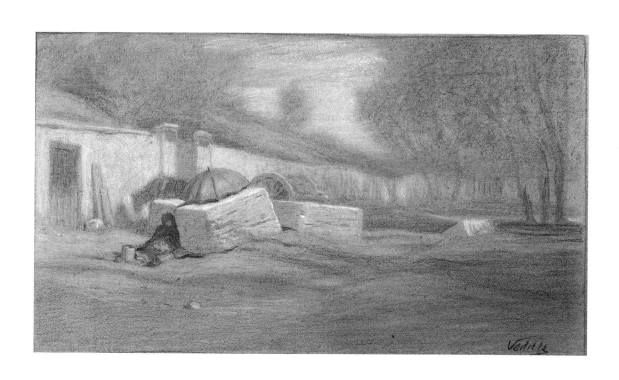

ABRAHAM WALKOWITZ (1878–1965)

68. *Bathers Along the Shore*

Watercolor and ink on paper
5⅜ × 7½ inches
Signed and dated lower right: A. Walkowitz 1907

Provenance:
Private Collection, MA

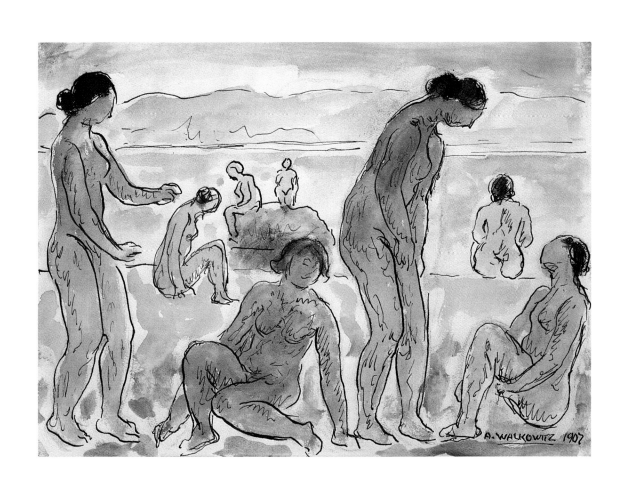

MAX WEBER (1881–1961)

69. *Three Girls*

Watercolor and pencil on board
10 × 8 inches
Signed and dated lower right: Max Weber 1912
Inscribed on the reverse: To Adah & Leonard in love and
 dearest friendship/July 28, 12 Max Weber

Provenance:
[The Downtown Gallery, New York, NY]
Mr. and Mrs. Max Zurier
The La Jolla Museum of Contemporary Art, La Jolla, CA

Exhibited:
Pasadena, CA, The Pasadena Art Museum, *Mr. and Mrs. Max
 Zurier* Collection, April 30-May 21, 1963, Cat. No. 64

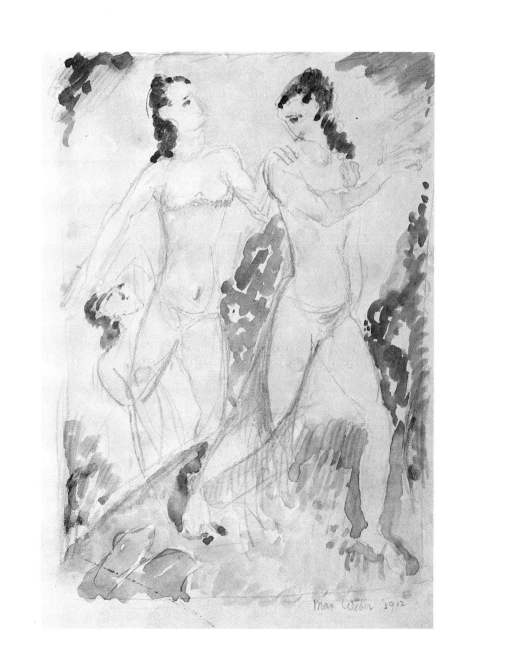

ANDREW WYETH (Born 1917)

70. *Afternoon Flight*, 1970

Watercolor and drybrush on paper
22⅜ × 28⅜ inches
Signed lower right: Andrew Wyeth

Provenance:
The artist
Mr. and Mrs. Joseph E. Levine, Greenwich, Connecticut
[Andrew Crispo Gallery, New York]
Thyssen-Bornemisza Collection

Exhibited:
Museum of Fine Arts, Boston, MA. *Andrew Wyeth* 1970,
 Cat. No. 49, illustrated in color
Andrew Crispo Gallery, New York, NY. *Ten Americans:*
 Masters of Watercolor 16 May-30 June, 1974, Cat. No. 153,
 illustrated in color
Metropolitan Museum of Art, New York, NY. *Two Worlds of*
 Andrew Wyeth: Kuerners and Olsons October 16,
 1976–February 6, 1977, Cat. No. 122, illustrated
Andrew Crispo Gallery, New York, NY, *20th Century Amer-*
 ican Masters 23 September-4 November 1978, Cat. No. 78
Federal Reserve Bank, Boston, MA. *New England*
 Connections 1978–79
Australian traveling exhibition. *American & Europe: A*
 Century of Modern Masters from the Thyssen-Bornemisza
 Collection 1979–80, Cat. No. 99
USA traveling exhibition. *American Masters: The Thyssen-*
 Bornemisza Collection 1984–86, Cat. No. 104, illustrated
 in color

Literature:
Museum of Fine Arts, Boston. *Andrew Wyeth* 1970, Cat.
 No. 99
Australian traveling exhibition. *America & Europe: A Cen-*
 tury of Modern Masters from the Thyssen-Bornemisza
 Collection 1979–80, Cat. No. 99
Gail Levin, *The Thyssen–Bornemisza Collection: Twentieth*
 Century American Painting, London 1988, Cat. No. 102,
 illustrated, p. 304–305

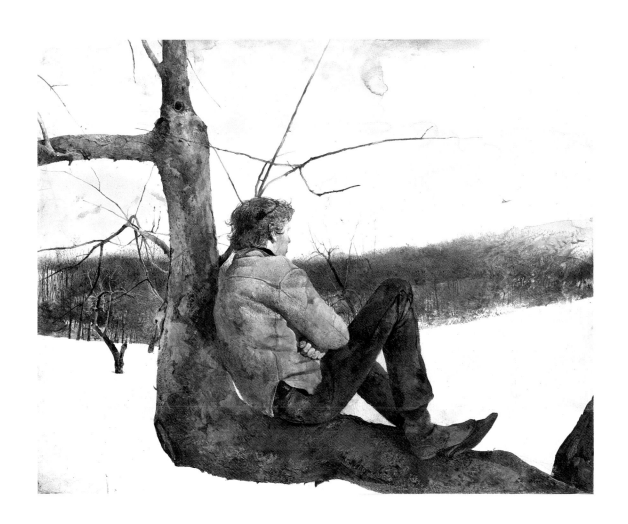